SPANNING TIME

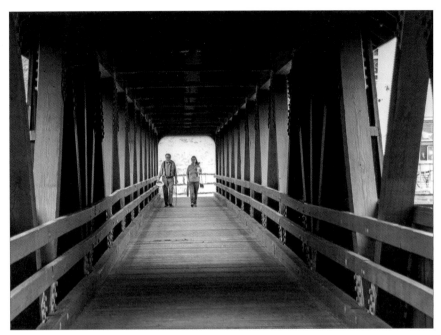

Littleton, Main Street

© 1986, 2017 Irene E. DuPont, text and images
All Rights Reserved. First edition 1986
Second edition 2017
ISBN: 978-1-937721-51-0
Library of Congress No.: 2017949031

Published by Peter E. Randall Publisher
PO Box 4726, Portsmouth, NH 03802
www.perpublisher.com

All images by Irene E. DuPont

Front Cover: Top: #15 Andover, Keniston
 Right: Old Man of the Mountain
 Bottom: #63 Henniker, New England College
Back Cover: #67 Packard Hill Bridge, Lebanon

To order, contact:
Irene E. DuPont
116 Gilford Street
Manchester, NH 03102

SPANNING TIME

New Hampshire's Covered Bridges & The Old Man of the Mountain

by Irene E. DuPont

SECOND EDITION

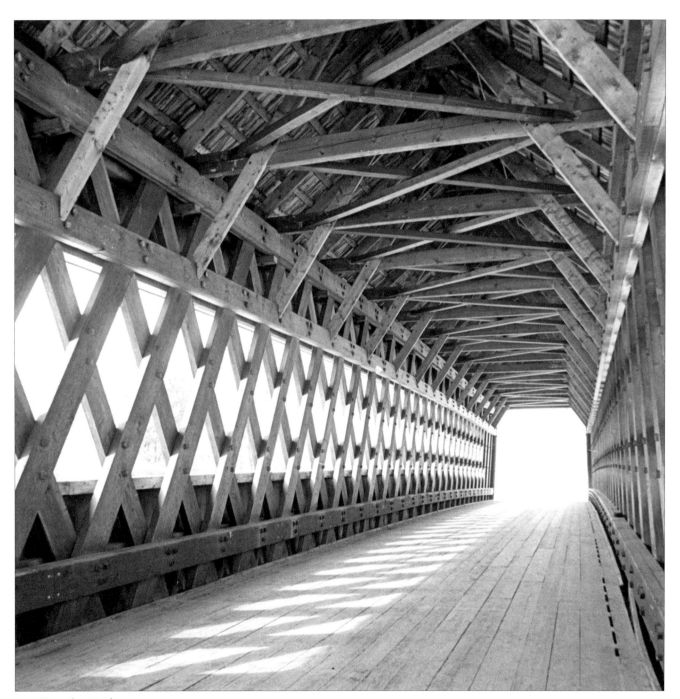

#63, *Henniker Bridge*

Acknowledgements

The author is most appreciative and grateful for the help and assistance her husband, Paul, has shown in finding these bridges. Without this support, this book would never have taken shape. She appreciates as well the work done by her brother, Alfred H. Blichmann, to scan and make ready all of her photographs for this book.

Much credit is due to Lisa Lundari, Armand Peters, and Marci Woodman for all their opinions, helpful hints, and assistance for the first edition of this book on covered bridges.

Image Notes from the Artist

This book introduces the first complete photographic collection of New Hampshire covered bridges (1983–2017). Along with publication of this 2017 second edition, a limited edition print of each bridge is available.

Each photograph is produced using an early photographic technique, "silver print", and is hand-colored in Marshall Oils, giving them the look of bygone days. Each original is processed to the finest archival standards. The Old Man of the Mountain photo is a C-Print on archival Kodak paper achieved on Kodak film ASA 200.

The Old Man of the Mountain collapsed on May 3, 2003. It was photographed on November 11, 2002, using ASA 200 color film and printed on archival Kodak paper. The prints may be acquired from the artist. To inquire, contact Ms. Irene E. DuPont by email: iirenee13@aol.com.

Contents

Acknowledgements .. 5

Image Notes from the Artist 5

Introduction .. 9

Single Span Bridges ... 11

 #2 Winchester, Coombs 12

 #4 Swanzey, Slate ... 13

 #7 Swanzey, Carleton 14

 #8 Hancock-Greenfield, County 15

 #9 Hopkinton, Rowell 16

 #12 Warner, Dalton .. 17

 #13 Warner, Waterloo 18

 #14 Bradford, Bement 19

 #15 Andover, Keniston 20

 #16 Andover, Cilleyville 21

 #17 Newport, Corbin 22

 #18 Langdon, Cold River 23

 #19 Langdon, Drewsville 24

 #21 Cornish, Blacksmith Shop 25

 #22 Cornish, Dingleton 26

 #23 Cornish, Blow-me-down 27

 #24 Plainfield, Meriden 28

 #25 Lyme, Edgell ... 29

 #29 Bath, Swift Water 30

 #31 Lancaster, Mechanic Street 31

 #32 Northumberland, Groveton 32

 #33 Columbia, NH-Lemington, VT, Columbia 33

 #34 Pittsburg, Clarksville 34

 #35 Pittsburg, Happy Corner 35

 #36 Pittsburg, River Road 36

 #38 Lincoln, Sentinel Pine 37

 #39 Lincoln, Flume .. 38

 #42 Campton, Turkey Jim 39

 #44 Plymouth, Smith 40

 #45 Sandwich, Durgin 41

 #46 Ossipee, Whittier 42

 #47 Conway, Swift River 43

 #49 Albany, Albany .. 44

 #51 Jackson, Honeymoon 45

 #65 Ashland, Squam River 46

 #67 Packard Hill Bridge, Lebanon 47

Multiple Span Bridges 48

 #1 Winchester, Asheulot 49

 #5 Swanzey, West Swanzey 50

 #6 Swanzey, Sawyer Crossing 51

#20 Cornish, NH–Windsor, VT 52

#27 Haverhill-Bath, Bath.. 53

#28 Bath, Bath .. 54

#30 Lancaster, NH–Lunenberg, VT, Mt. Opne....... 55

#37 Stark, Stark .. 56

#41 Campton Blair .. 57

#48 Conway, Saco River .. 58

Privately Owned and Railroad Bridges 59

#10 Hopkinton, Railroad Bridge 60

#43 Campton, Bump .. 61

#50 Bartlett, Bartlett .. 62

#57 Newport Pier, or Chandler Station 63

#58 Newport, Wrights ..64

#60 Hillsboro, Hillsboro.. 65

#63 Henniker, New England College 66

#64 North Woodstock, Lincoln 67

John Goffe Mill Bridge, Bedford.............................. 68

Littleton, Main Street ..69

Rumney ... 70

Stowell Road, Baboosic Brook Bridge, Merrimack ...71

Woodstock, Lincoln... 72

Bridge Truss Frames .. 73

Timeline of the Old Man of the Mountain................74

"The Old Man Made His Notch in Time"76

Photograph of the Old Man of the Mountain,
November 11, 2002..77

Bibliography..78

About the Author..79

Photograph of the Old Man of the Mountain,
September 13, 2002 ... 80

The author capturing #13, Warner

Introduction

Spanning Time is inspired by the era going back to the 1800s when the White Mountains began to occupy a special place in the history of America. Men discovered the picturesque highlands of the mountains, which formed a relatively compact geographic area and chain with the Appalachian Mountains—the glacier-worn peaks dominated by the Old Man of the Mountain, Indian Head, and Mount Washington.

In 1805, Nathaniel Hall, Luke Brooks, and Francis Whitcomb reported seeing the profile of the Old Man of the Mountain, and one hundred and fifty years later, on April 10, 1945, it became New Hampshire's state emblem, along with the motto "Live free or die," as shouted by John Stark.

Tourists found their way by wagon, stage coach, and horse, pushing their way into the heart of the mountains; therefore, bridges were taking shape. Many traveled over roads where covered bridges were built to allow them to cross rivers and streams to get to their destination.

The covered bridge is an intrinsic part of our New England heritage. The Northeast acknowledges 192 covered bridges; 59 of these spans dot New Hampshire's granite mountains and pined forests. The state's covered bridges are representative of the various styles of crossings used in early New England. These pathways were a tribute to the great advances in bridge engineering of the day.

A bridge is defined as a structure erected to furnish a passageway over river, stream, or depression. The covered roadways also offered communities early billboard advertising. The local merchants posted signs for powders, potions, and cures. County fairs, political rallies, and church socials vied for wall space. And let us not forget the appeal of the covered bridge to young lovers. The "kissing bridge" afforded couples a quick embrace or stolen kiss in the darkness of its cover.

The covered bridge's practicality in community living cannot be overstated. It contained early road, warning, and speeding signs. Tolls were levied by bridge builders: 1 penny per cow crossing, 3 pennies for a carriage drawn by two horses, children traversing to school were free.

This unique silver print photographic collection by Irene E. DuPont allows each individual structure to be admired in its natural setting. All of the covered bridge images and Francestown's Main Street were on exhibit in the Rotunda, Washington, DC, Cannon House Office Building, September 29, 1993, and documented in the 103 d, Congressional Record, Volume 139, No. 130 sponsored by Time-Warner Communications and House Representative Dick Swett of New Hampshire.

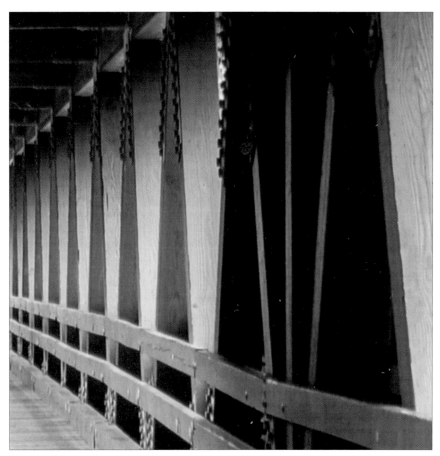
Detail of the walking bridge, Main Street, Littleton

SINGLE SPAN BRIDGES

The bridges are listed by number (assigned by the state),
the name of town in which the bridge is located,
and the name by which the bridge is generally known.
All include a location, as these seem to be a favorite to find.

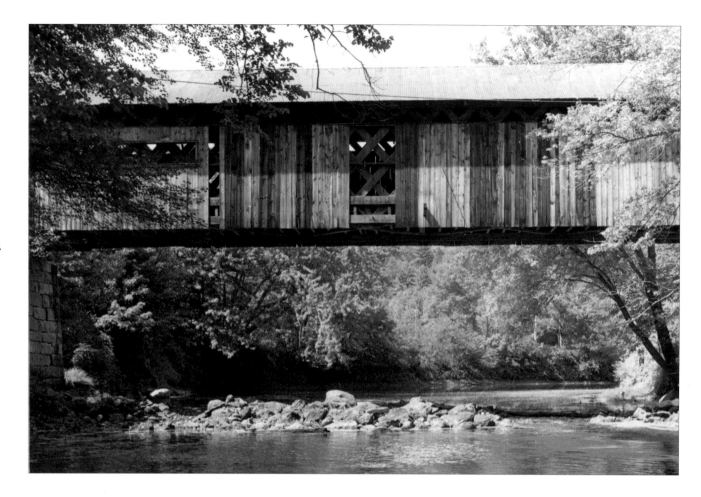

#2 Winchester, Coombs

Single span, 118 feet

Built in 1837, over the Asheulot River

Stone abutments were carefully fitted without mortar.

West of NH 10, ½ mile southwest of Westport

Town Lattice Truss

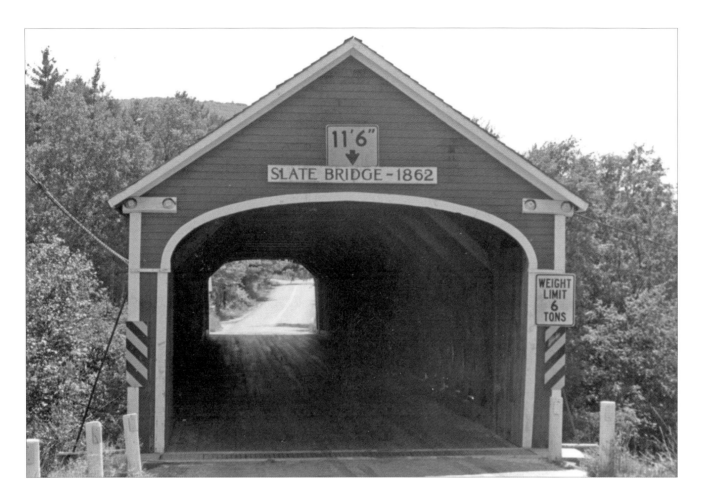

#4 Swanzey, Slate

Single span, 142½ feet

Built in 1862, over the Asheulot River

This bridge, built with iron turnbuckle rods, was often revisited to tighten and tune up any sags or looseness, keeping it in shape.

East of NH Route 10

Town Lattice Truss

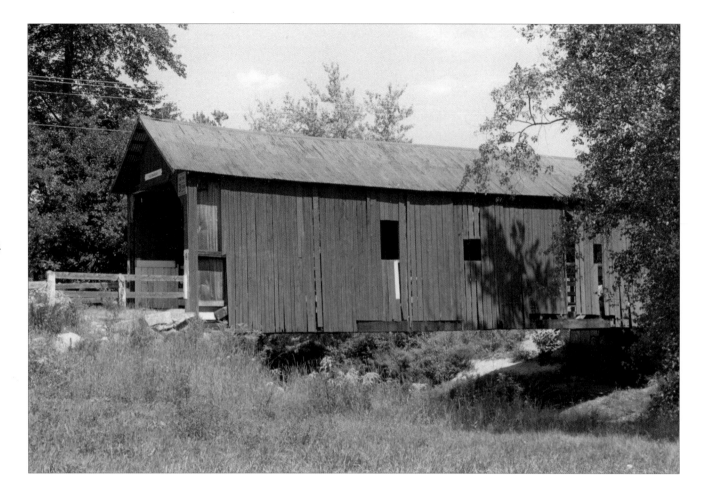

#7 Swanzey, Carleton

Single span, 67 feet

Built in 1867 by barn builders, and rebuilt in 1869 over the south branch of the Ashuelot River

East of NH 32

Queenpost Truss

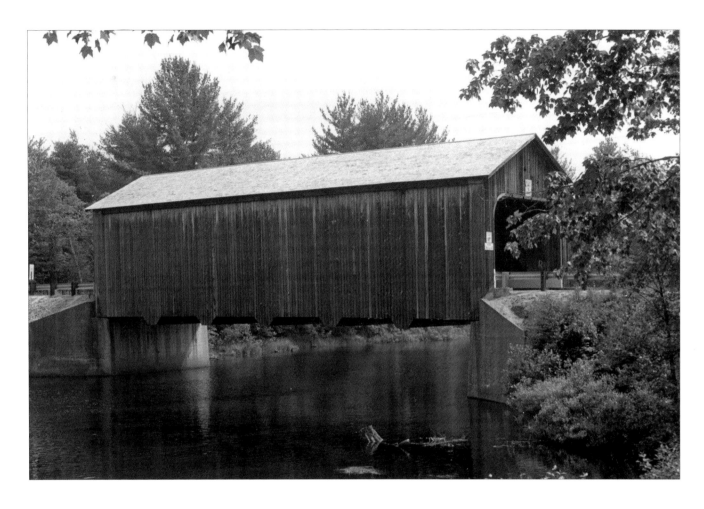

#8 Hancock-Greenfield, County

Single span, 88 feet

Built in 1937, over the Contoocook River

This bridge has all the appearance of antiquity, but is a modern version of a covered bridge.

1 mile east of Route 202

Pratt Timber Truss

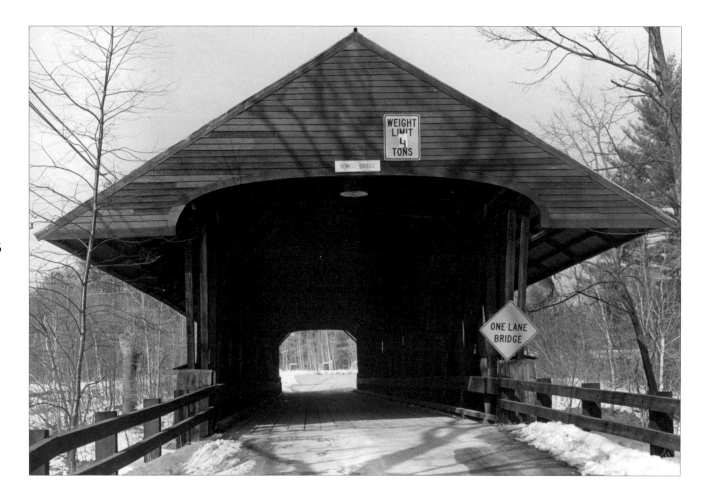

#9 Hopkinton, Rowell

Single span, 167 feet

Built in 1853, over the Contoocook River, rebuilt 1965

In 1930, a concrete pier was built but was removed years later, reverting back to a single span.

North of NH 127 at West Hopkinton

Burr and Long Truss

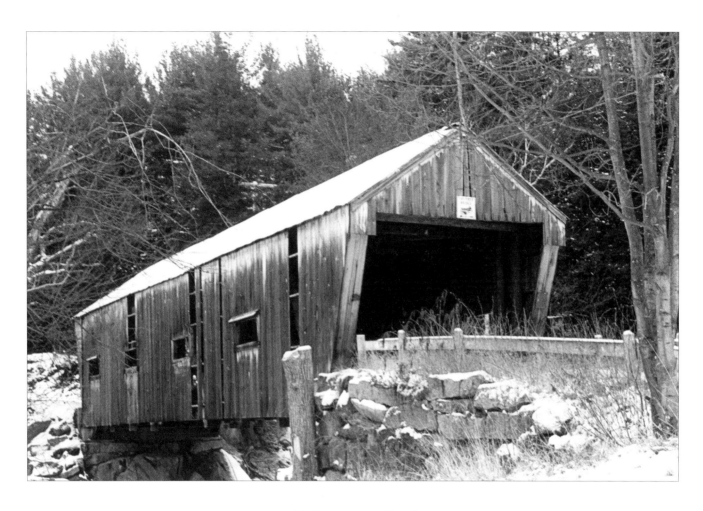

#12 Warner, Dalton

Single span, 86 feet

Built in 1800, over the Warner River, rebuilt in 1963

South of NH 103, Warner Village

Queenpost Truss

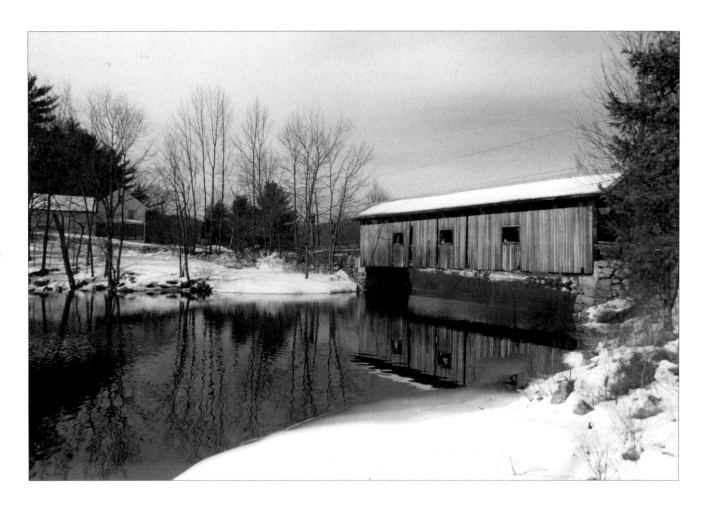

#13 Warner, Waterloo

Single span, 76 feet

Built in 1840, over the Warner River. Rebuilt in 1957 and again in 1970

South of NH 103, 2 miles west of village

Town Lattice Truss

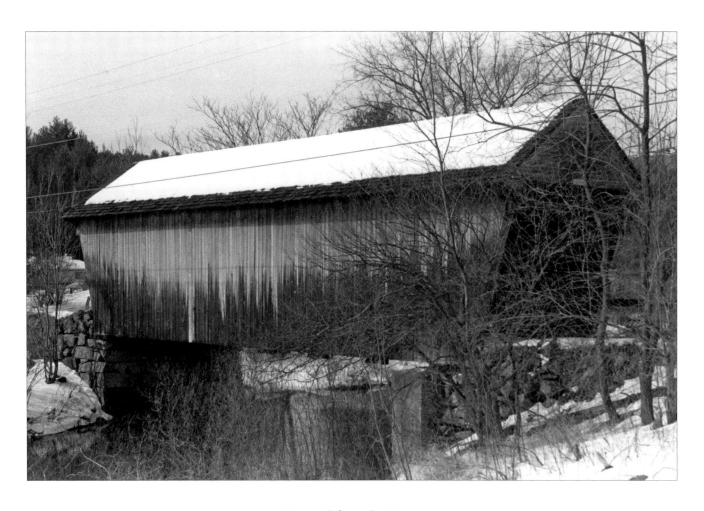

#14 Bradford, Bement

Single span, 71 feet

Built in 1854, over the west branch of the Warner River, and repaired in 1968

South of junction NH 103 & 114

Long Truss

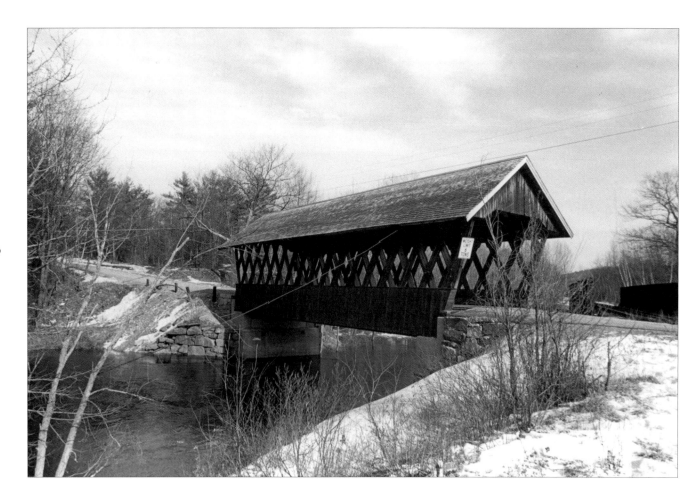

#15 Andover, Keniston

Single span, 70 feet

Built in 1882, over the Blackwater River

South of US 4, 1 mile west of Andover Village

Town Lattice Truss

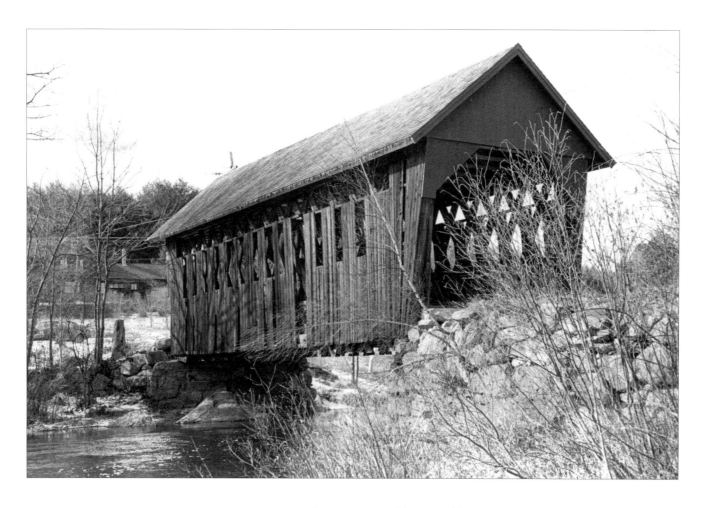

#16 Andover, Cilleyville

Single span, 49 feet, foot traffic only

Built in 1887 over Pleasant Stream, and bypassed by the highway in 1959

NH 11 at junction of NH 4A

Town Lattice Truss

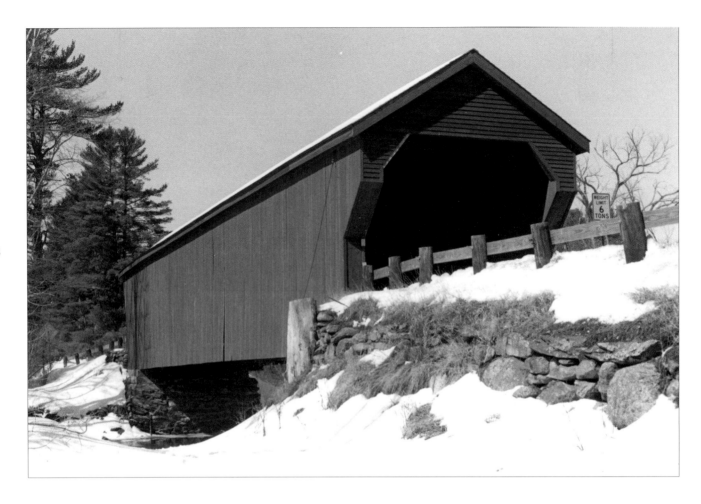

#17 Newport, Corbin

Single span, 105 feet

Built in 1835, over the Croydon Branch of Sugar River, and rebuilt 1994

West of NH 10 on North Newport Road

Town Lattice Truss

#18 Langdon, Cold River

Single span, 81 feet, foot traffic only

Built in 1869, over the Cold River, and bypassed by the highway in 1964

North of NH 123A, 2 miles north of Alstead Village

Town Lattice Truss

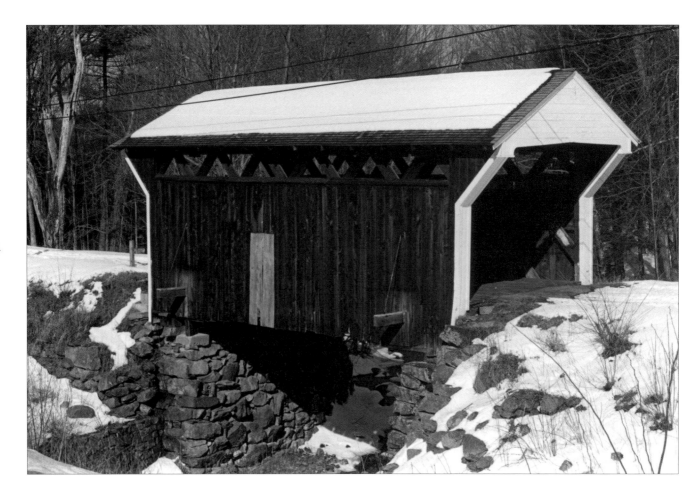

#19 Langdon, Drewsville

Single span, 35 feet, foot traffic only

Built in 1874, over Great Brook, and bypassed by the highway in 1955

Known as the Prentiss Bridge, it is the shortest covered bridge in New Hampshire.

1 mile south of NH 12A at Langdon Village

Town Lattice Truss

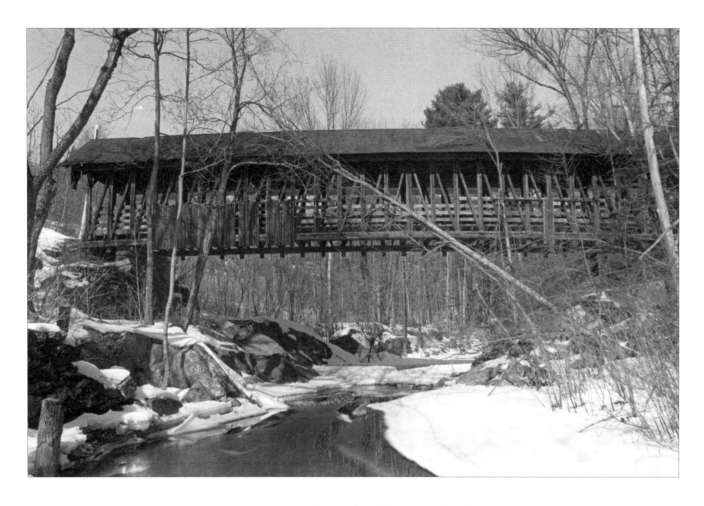

#21 Cornish, Blacksmith Shop

Single span, 96 feet

Built in 1881, over Mill Brook

Constructed in Town Hall yard then rolled to the site

2 miles east of NH 12A

Multiple Kingpost Truss

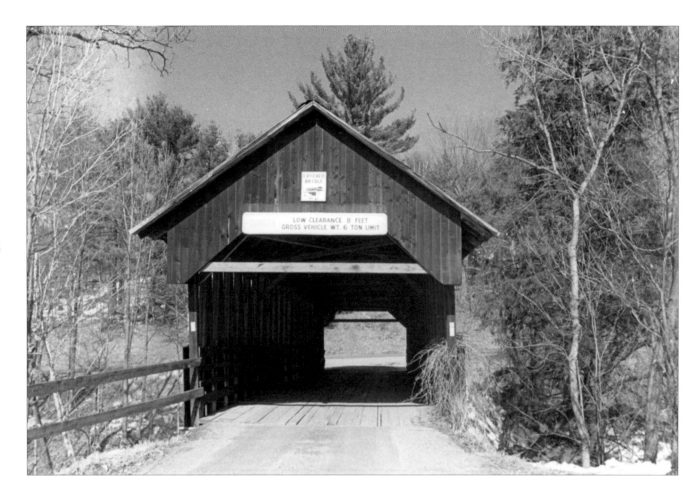

#22 Cornish, Dingleton

Single span, 81 feet

Built in 1882, over Mill Brook

Constructed in schoolyard then rolled to the site. The bridge was damaged by an over-height vehicle in 2016, but the driver came forth and repair was accomplished. This bridge is fixed with security cameras because of accidents that have occurred.

1 mile east of NH 12A

Multiple Kingpost Truss

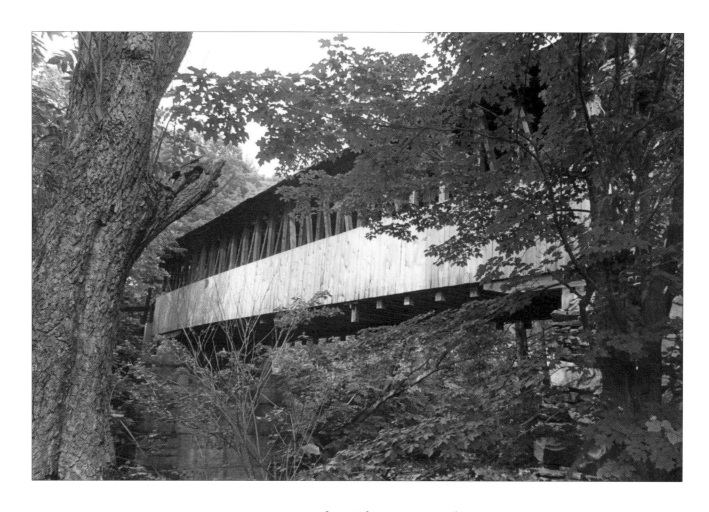

#23 Cornish, Blow-me-down

Single span, 90 feet

Built in 1877, over Blow-me-down Brook

South of NH 12A, southwest of Plainfield

Multiple Kingpost Truss

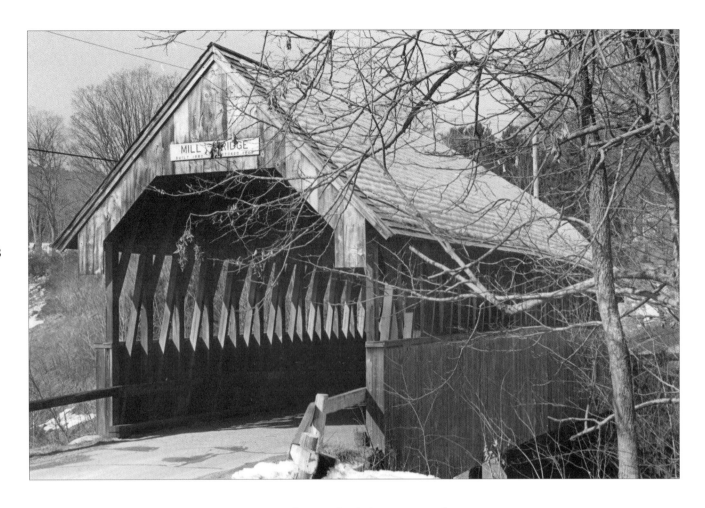

#24 Plainfield, Meriden

Single span, 80 feet

Built in 1880, over Blood's Brook, and restored to a 15-ton capacity using steel stringers in 1963

1 mile northwest of NH 120

Multiple Kingpost Truss

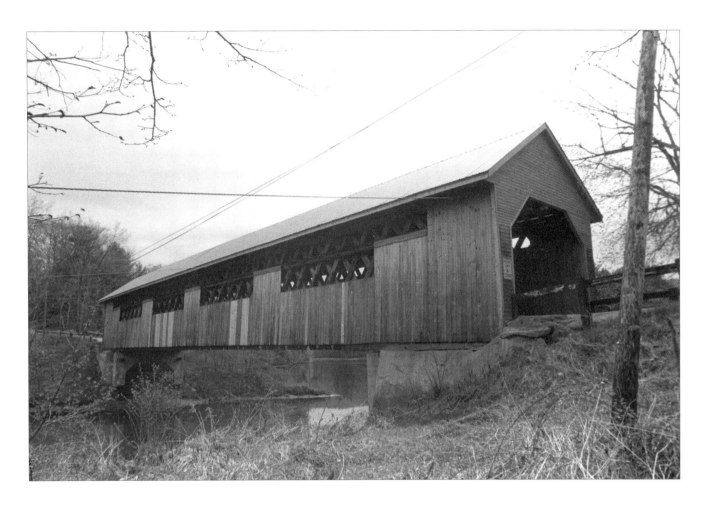

#25 Lyme, Edgell

Single span, 154 feet

Built in 1885, over Clay Brook

The trusses were constructed on Lyme Common and then transported to the site.

South of NH 10, 2 miles south of Oxford Village

Town Lattice Truss

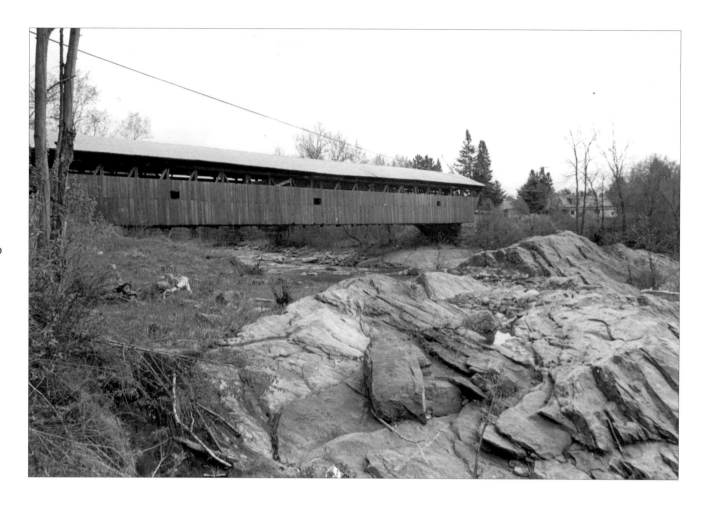

#29 Bath, Swift Water

Single span, 174 feet

Built in 1849, over the Ammonoosuc River

North of NH 112 at Swift Water

Paddleford Truss, added arch

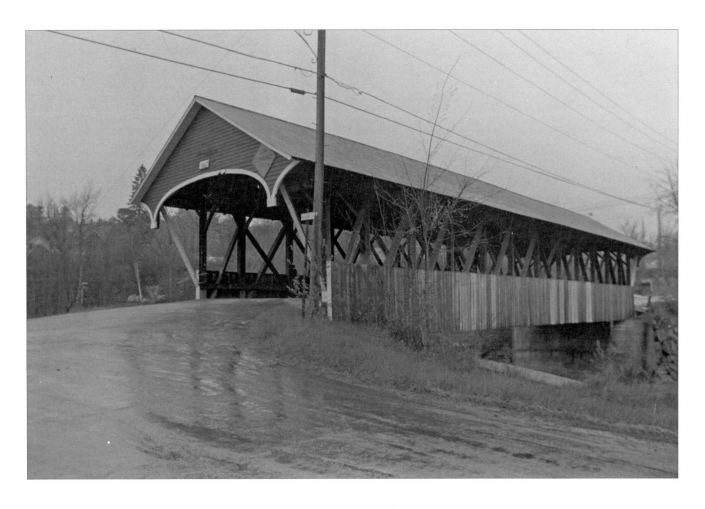

#31 Lancaster, Mechanic Street

Single span, 94 feet

Built in 1862, over the Israel River

East of US 2, on US 3 in Lancaster Village

Paddleford Truss

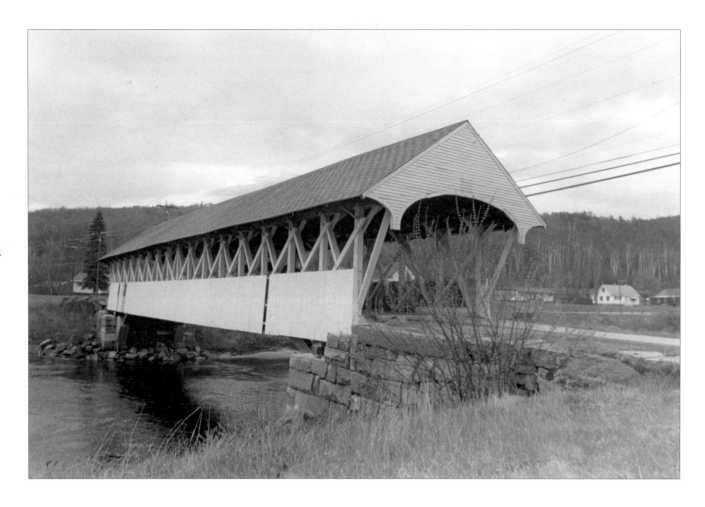

#32 Northumberland, Groveton

Single span, 136 feet, foot traffic only

Built in 1852, over the Ammonoosuc River, bypassed by highway in 1939, and rebuilt 1964–65

East of US 3 in the village of Groveton

Paddleford Truss

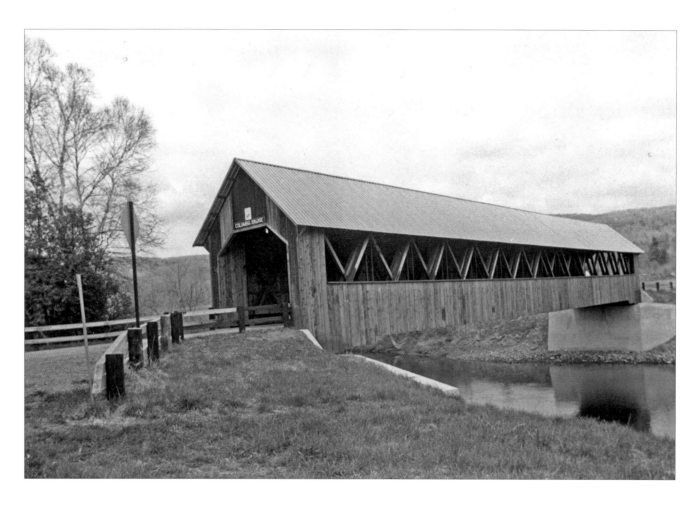

#33 Columbia, NH-Lemington, VT, Columbia

Single span, 145 feet

Built in 1912, over the Connecticut River

West of NH 3, 4 miles south of Colebrook Village

Howe Truss

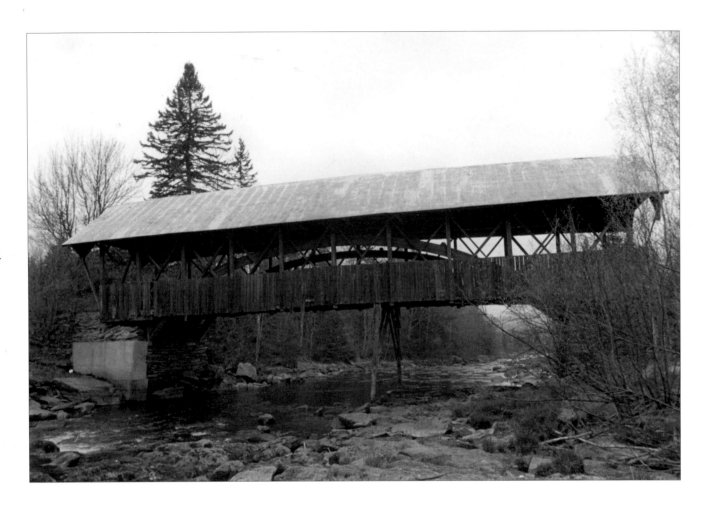

#34 Pittsburg, Clarksville

Single span, 88 feet

Built in 1876, over the Connecticut River, connecting the towns of Pittsburg and Clarksville

South of US 3, 1 mile west Pittsburg Village

Paddleford Truss, with added arch

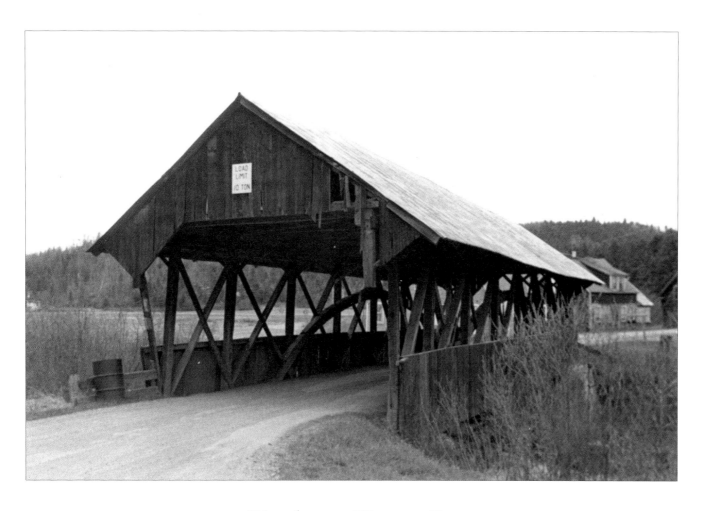

#35 Pittsburg, Happy Corner

Single span, 61 feet

Built in 1800s, over Perry Stream

One of the oldest bridges in northern New Hampshire

East of US 3, 6 miles north of Pittsburg Village on Hill Road

Paddleford Truss, with added arch

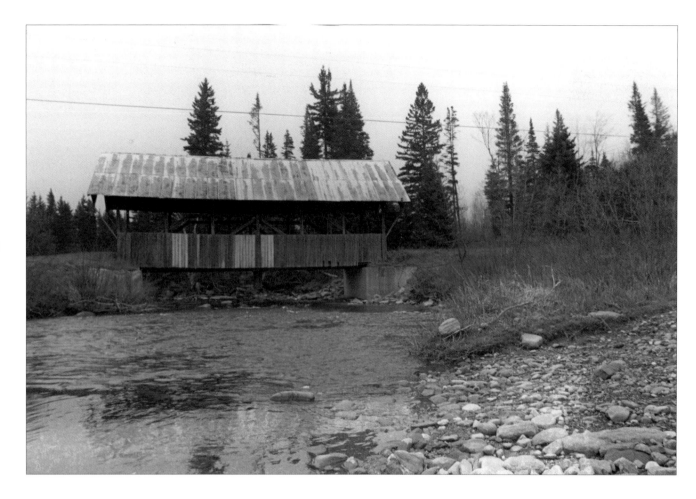

#36 Pittsburg, River Road

Single span, 51 feet

Built in 1858, over the Perry Stream

1 mile east of Route 3, on road to Lake Francis State Park

Queenpost Truss

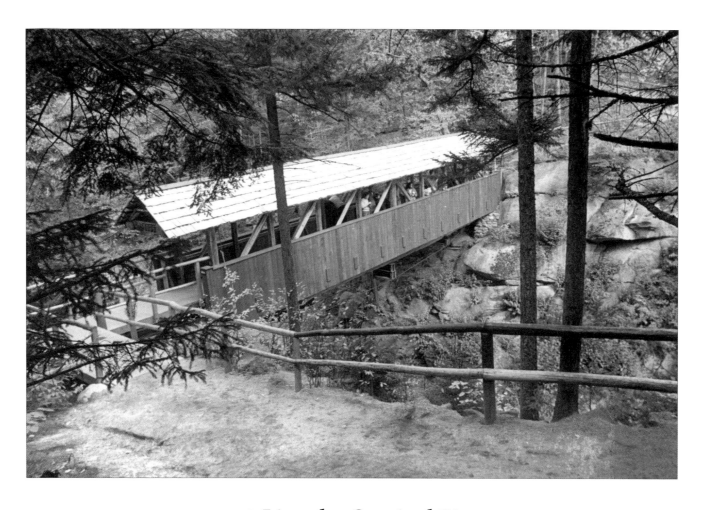

#38 Lincoln, Sentinel Pine

Single span, 61 feet

Built in 1939, over the Pemigewasset River,
spans the Flume Gorge at the pool, foot traffic only

East of US 3

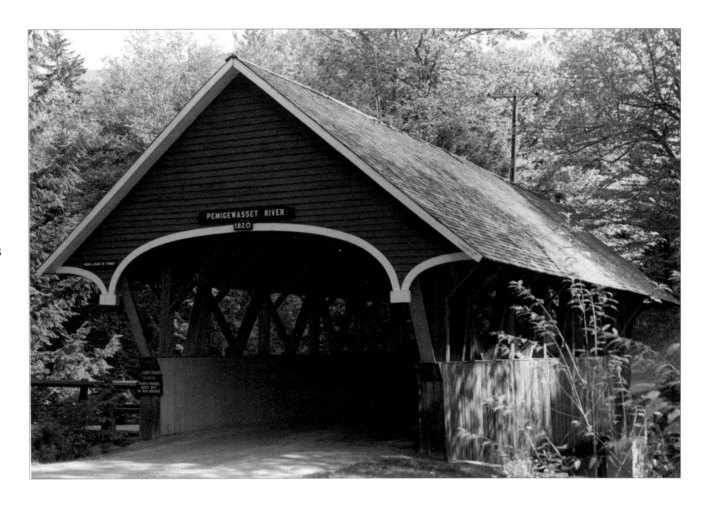

#39 Lincoln, Flume

Single span, 50 feet

Built in 1886, over the Pemigewasset River

Built in Flume Reservation to facilitate tourists coming by bus to the Flume Base. Sidewalk was added for foot traffic.

East of US 3

Paddleford Truss

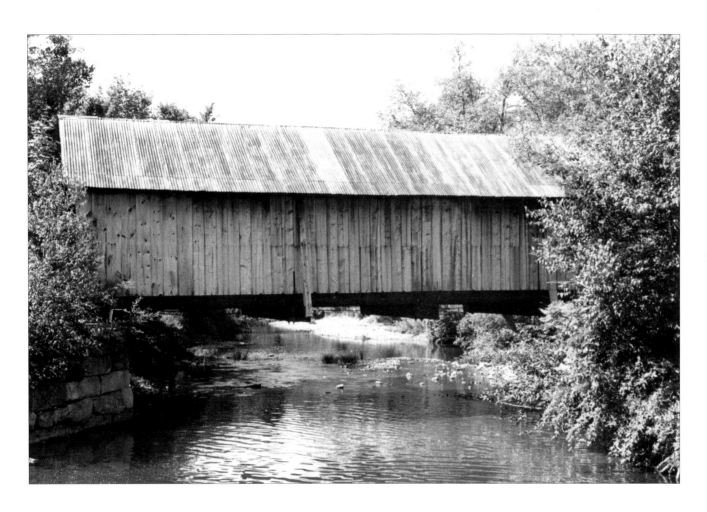

#42 Campton, Turkey Jim

Single span, 60 feet

Built in 1883, over the West Branch Brook, it was rebuilt in 1958 after it was demolished by a rain storm and flood.

Bridge allows the campers to enter the property of a camp ground.

½ mile east of US 3

Queenpost Truss

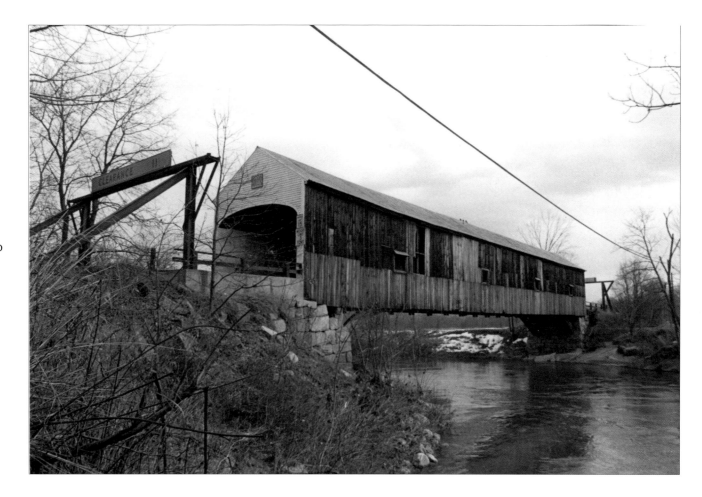

#44 Plymouth, Smith

Single Span, 150 feet

Built in 1850, over the Baker River, rebuilt in 1958, adding wires for additional support, rebuilt again in 2001, with the cost of $3.3 million

On Smith Bridge Road, ½ mile north of NH 25

Long Truss, with added arch

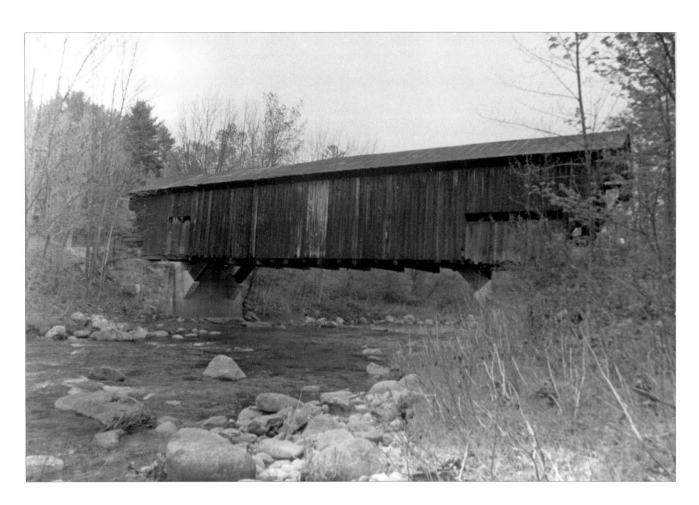

#45 Sandwich, Durgin

Single Span, 96 feet

Built in 1869, over the Cold River

Bridge built high enough to escape a flood crest

1½ miles north of Route 113

Paddleford Truss, with added arches in 1967

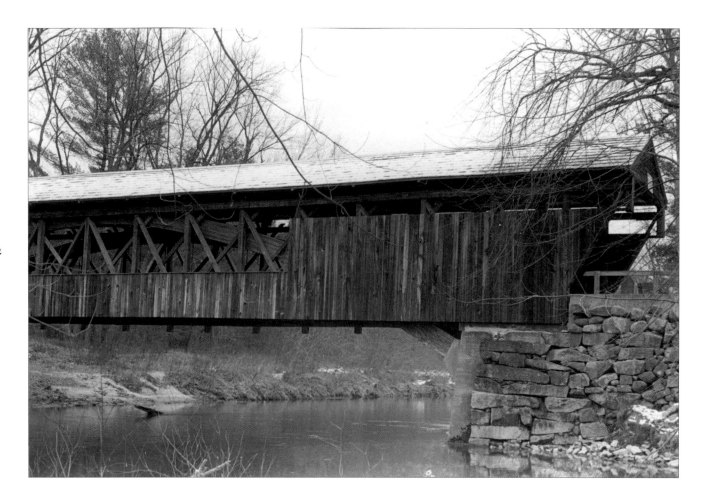

#46 Ossipee, Whittier

Single span, 132 feet

Built in 1870, over the Bearcamp River

In 1958, steel was added to protect the upper bracing of the bridge.

West of NH 16

Paddleford Truss, with added arch

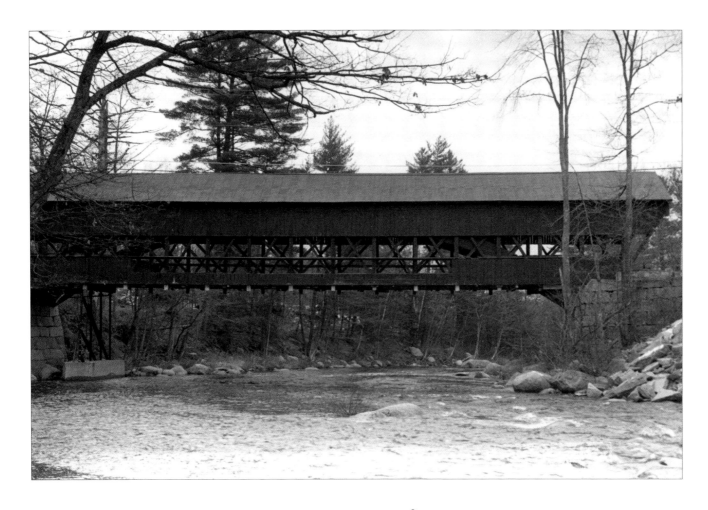

#47 Conway, Swift River

Single span, 129 feet

Built in 1850, over the Swift River. Bridge carried away by the flood and rebuilt in 1869 and 1870.

½ mile north of NH 16

Paddleford Truss, with added arch

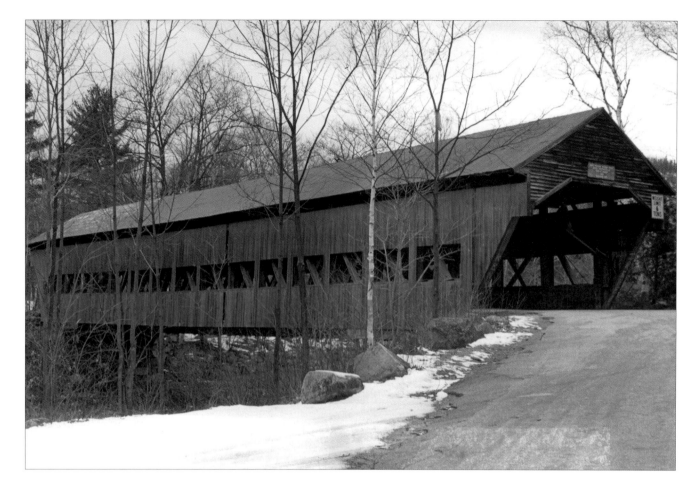

#49 Albany, Albany

Single span, 120 feet

Built in 1858, over the Swift River

The Forest Service repaired the wood floor timbers with steel stringers.

North of the Kancamagus Highway, 6 miles west of Conway

Long Truss, with added arch

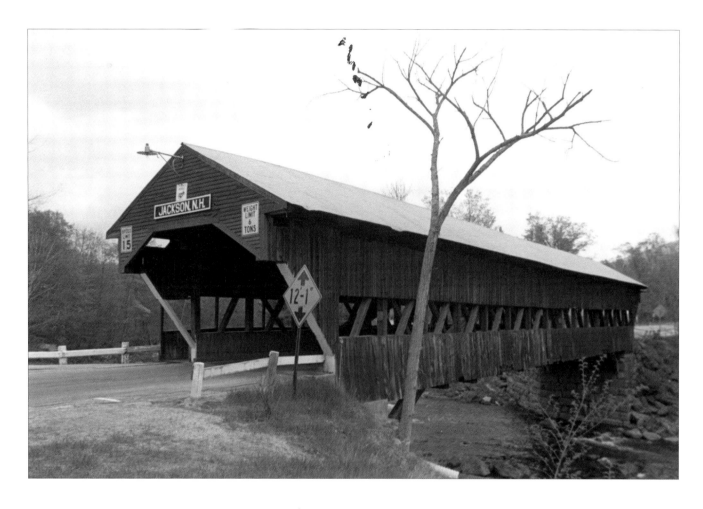

#51 Jackson, Honeymoon

Single span, 122 feet

Built in 1876, over the Ellis River, rebuilt 1965

Sometimes called "Courting Bridge"

NH 16A at junction with NH 16 at Jackson Village

Paddleford Truss, with added sidewalk

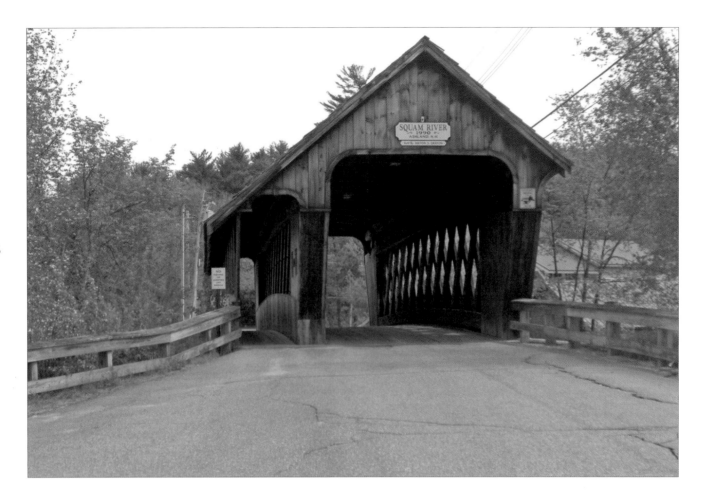

#65 Ashland, Squam River

Single span, 61 feet

Built in 1990, over the Squam River

One car lane and a walking lane, built by Milton S. Grafton and Sons

Route 3

Pratt Truss

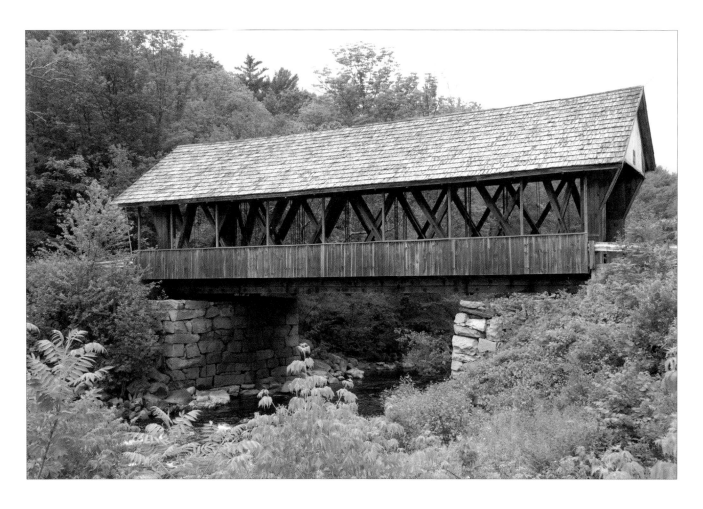

#67 Packard Hill Bridge, Lebanon

Single span, 76 feet

Open timber bridge, built in 1780, but replaced in 1991 as a covered bridge for $316,500

On Riverside Drive spanning the Mascoma River in Lebanon

Route 89 to Route 4

Howe Truss

MULTIPLE SPAN BRIDGES

The bridges are listed by number (assigned by the state),
the name of town in which the bridge is located,
and the name by which the bridge is generally known.
Descriptions include the location and route area,
if one wants to find these.

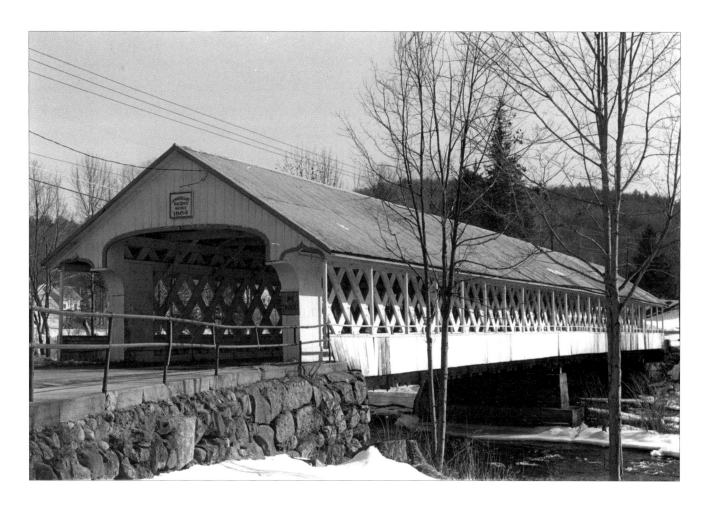

#1 Winchester, Asheulot

Two-span, 169 feet

Built in 1864, over the Asheulot River, at a cost of $4,650

This bridge has a walkway for people to travel across on foot. It was given the number #1 by the state of New Hampshire, as that is where the state decided to begin the numbering system of the covered bridges.

South of NH 119 at Asheulot

Town Lattice Truss

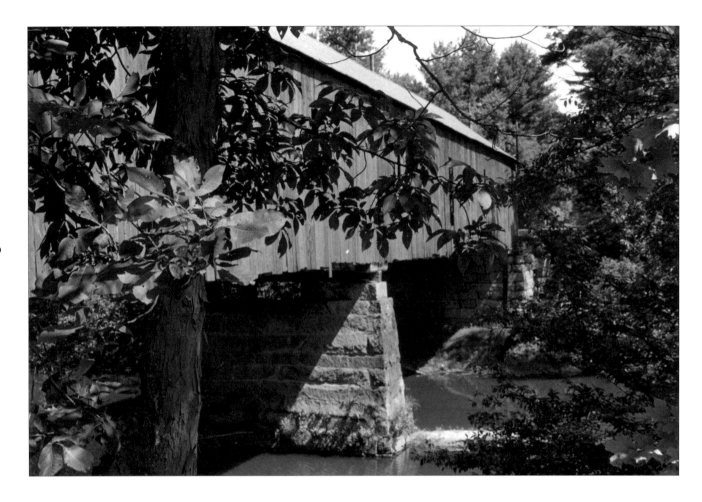

#5 Swanzey, West Swanzey

Two-span, 155 feet

Built in 1832, over the Ashuelot River

This bridge once had two sidewalks, but soon lost one side to wear.

East of NH 10 at West Swanzey

Town Lattice Truss

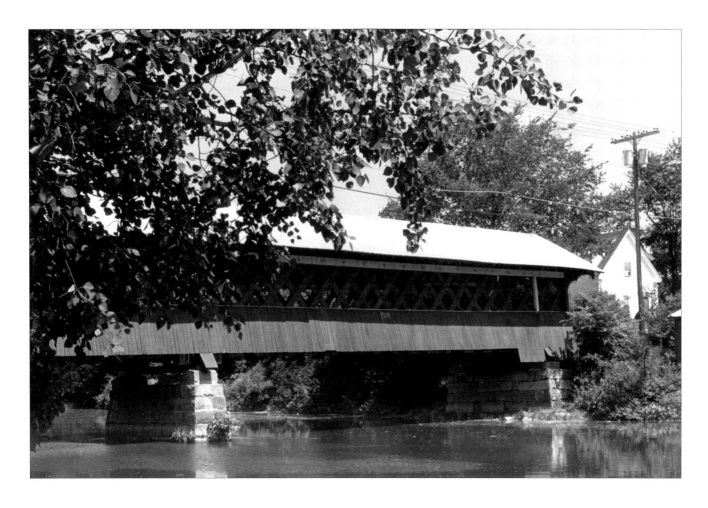

#6 Swanzey, Sawyer Crossing

Two-span, 159 feet

Rebuilt in 1859, over the Ashuelot River

This bridge replaces the one which was built near the ancient Indian community of Swanzey.

1 mile north of NH 10 in the town of Swanzey

Town Lattice Truss

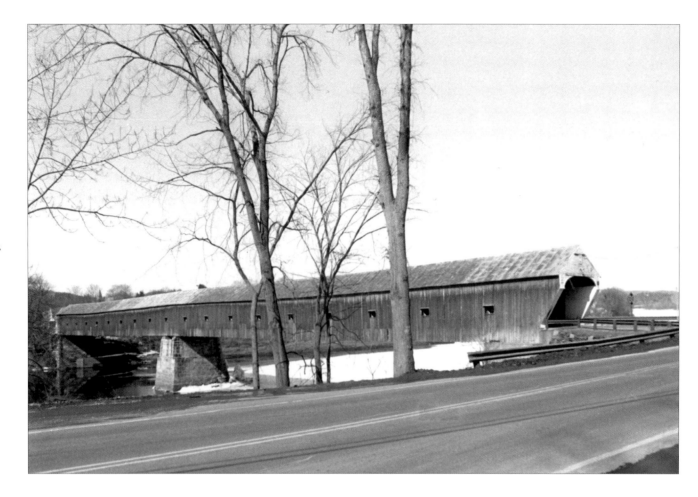

#20 Cornish, NH–Windsor, VT

Two-span, 450 feet

Different bridges were built on this site in 1796, 1824, and 1828 over the Connecticut River. Then, in 1866, it was renovated for a cost of $9,000. It was restructured and timbers were replaced in 1954. Rebuilt in 1988.

Built as a toll bridge by a private corporation, purchased by the state of New Hampshire in 1936 and made toll free in 1943. This bridge is the longest wooden covered bridge to carry automobiles in America, as well as the longest two-span covered bridge. Designated as a National Historic Civil Engineering Landmark in 1970.

West of NH 12A

Town Lattice Truss

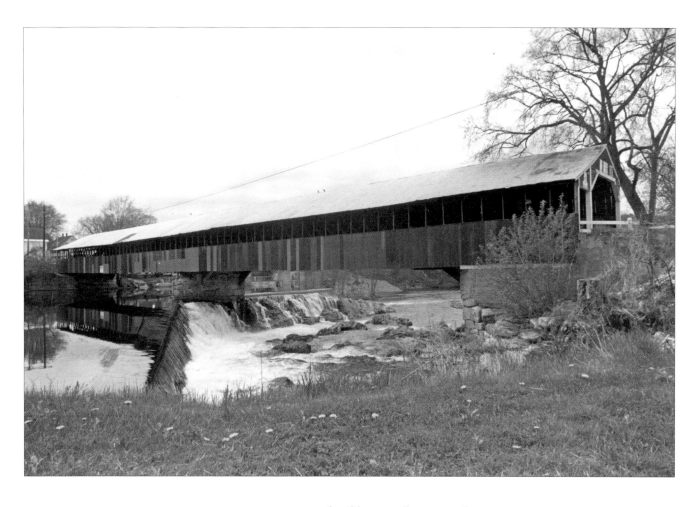

#27 Haverhill-Bath, Bath

Two-span, 256 feet

Built in 1827–1829, over the Ammonoosuc River

This is the oldest authenticated covered bridge in NH, with a sidewalk giving it a saltbox effect.

NH 135, ¼ mile north of US 302

Town Lattice Truss

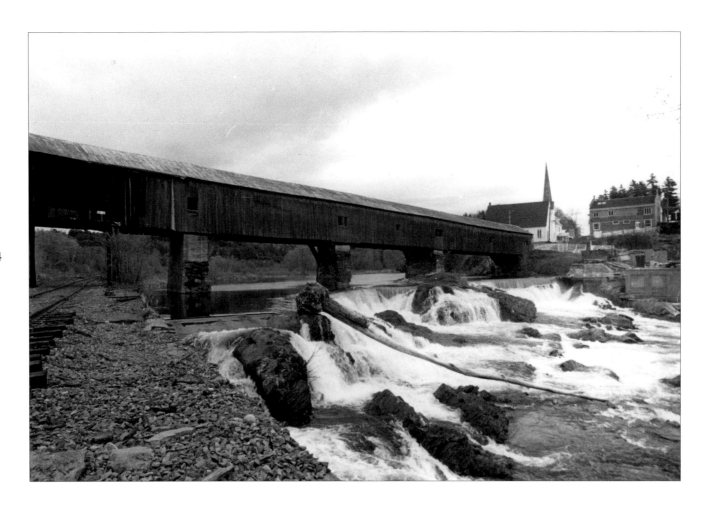

#28 Bath, Bath

Four-span, 375 feet

Built in 1832, over the Ammonoosuc River

New overlapping arches were added when the bridge was raised over the railroad tracks.

West of US 302 at Bath Village

Burr Truss, old hewed trusses

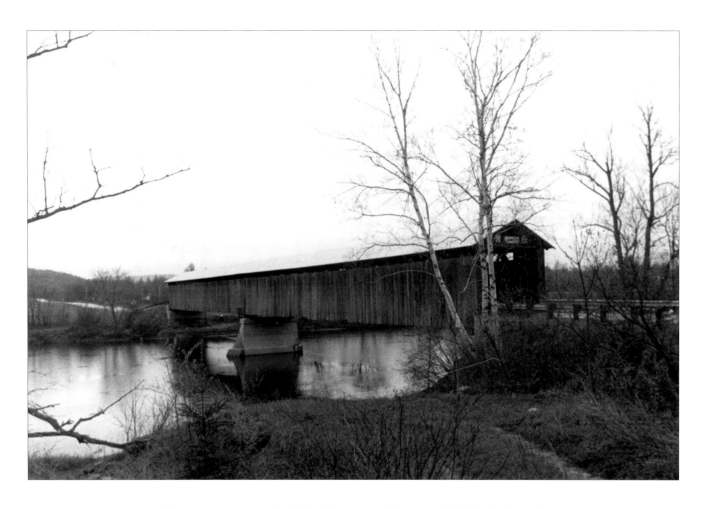

#30 Lancaster, NH–Lunenberg, VT, Mt. Opne

Two-span, 288 feet

Built in 1911, over the Connecticut River

5 miles west of Lancaster

Howe Truss

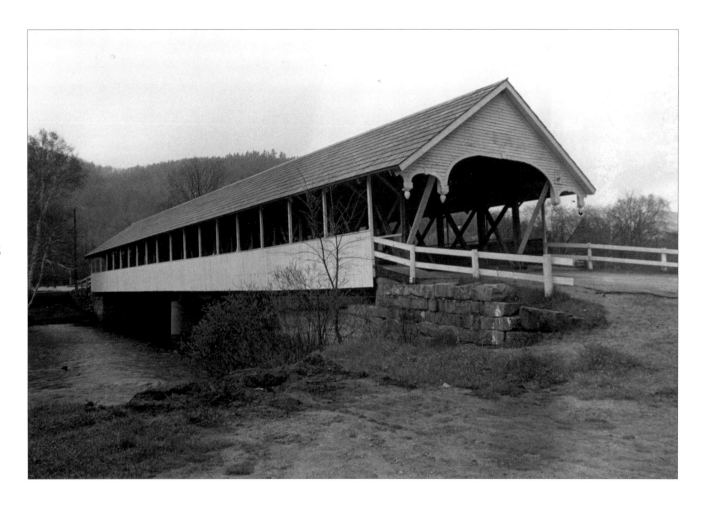

#37 Stark, Stark

Two-span, 134 feet

Built in 1862, over the Ammonoosuc River, it was carried away by a flood, in the 1890s. It was rebuilt in 1949 with steel stringers and arches removed.

Due to an outcry of the people, the New Hampshire Department of Transportation (NHDOT) decided to restore it. Jim Ligon called for a partial renovation and proceeded to bring the bridge back. Opening ceremonial ribbon cutting on June 27, 2016.

Northwest of NH 10 at Stark Village

Paddleford Truss, with added arches

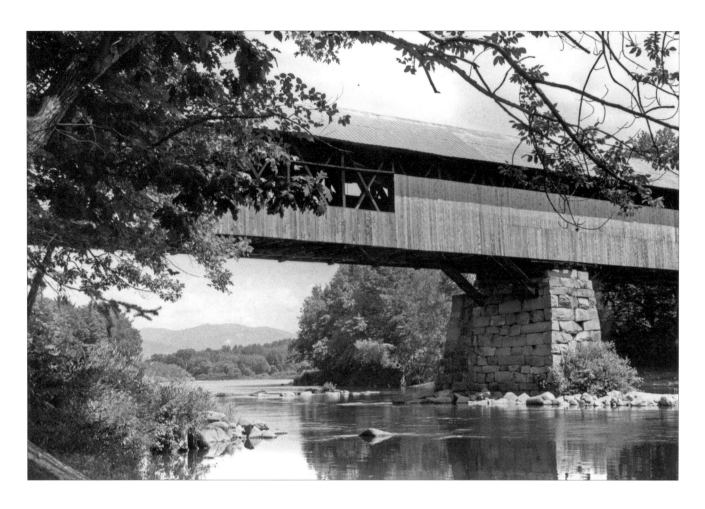

#41 Campton Blair

Two-span, 292 feet

Built in 1828, renewed 1869, over the Pemigewasset River

East of US 3, 2 miles north of Livermore Falls

Long Truss, with added arch

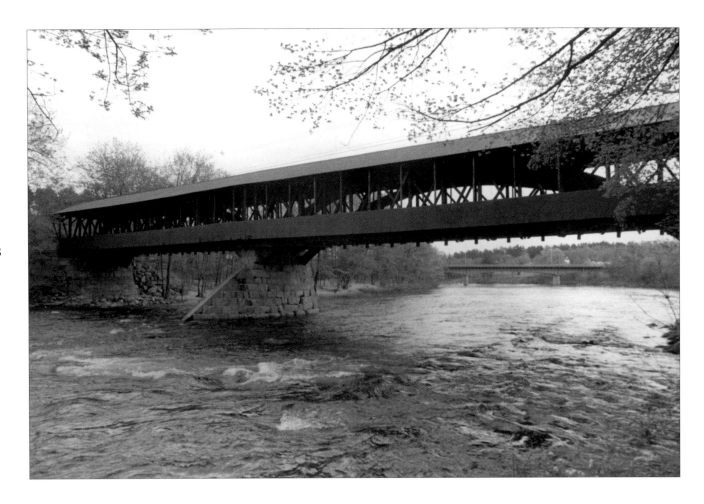

#48 Conway, Saco River

Two-span, 240 feet

Built in 1890, over the Saco River, two sidewalks were later added

1/4 mile north of NH 16 at Davis Park

Paddleford Truss, with added arch

PRIVATELY OWNED AND RAILROAD BRIDGES

The bridges are listed by number (assigned by the state),
the name of town in which the bridge is located,
and the name by which the bridge is generally known.
Some private bridges are owned by persons, resorts,
or companies and, therefore, are not numbered by
the state. Those are arranged alphabetically.

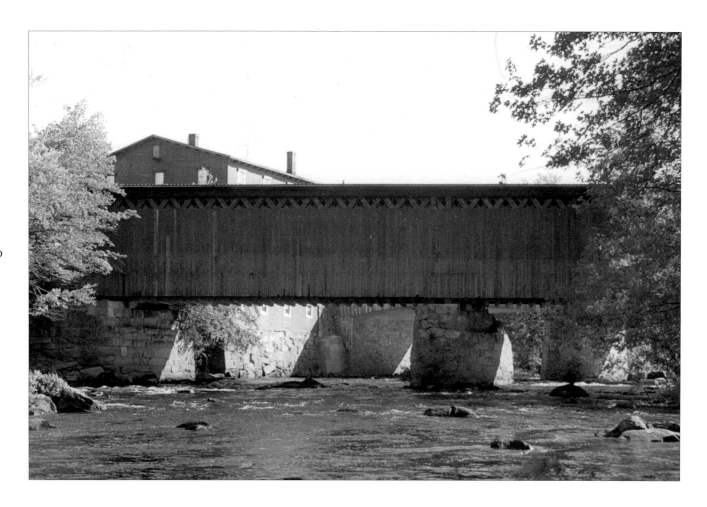

#10 Hopkinton, Railroad Bridge
Claremont & Concord Railroad bridge

Two-span, 157 feet

Built in 1849, over the Contoocook River, rebuilt in 1889

One of the first bridges constructed by the railroad company from Concord to Bradford, it was damaged by a flood in 1936 and a hurricane in 1938, but was restored. It was used as a warehouse until 1989, then became public property. Listed on the National Register of Historic Places, it is the world's oldest surviving covered railroad bridge. Plans are underway to restore the bridge, along with the historic depot nearby.

East of NH 103 in the center of Contoocook Village

Town Lattice Truss

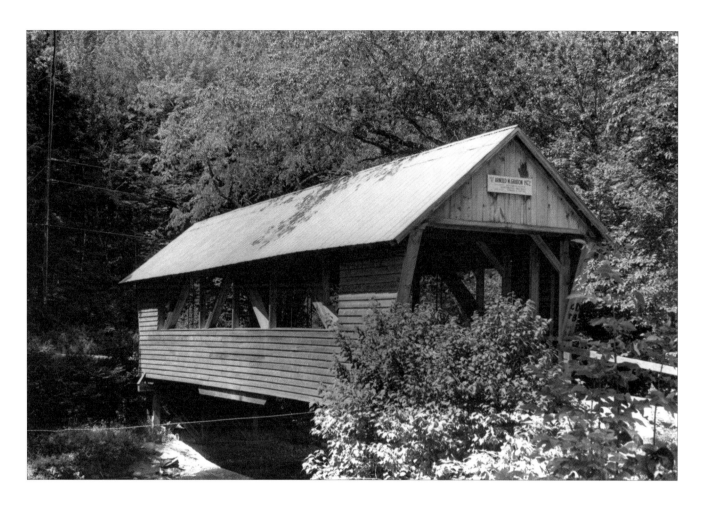

#43 Campton, Bump

Single span, 68 feet

Privately owned, built in 1877, rebuilt in 1972, over the Beebe River

Bridge supported by "horses" instead of abutments, and siding runs lengthwise

1 mile east of NH 175, at Campton Hollow

Queenpost Truss

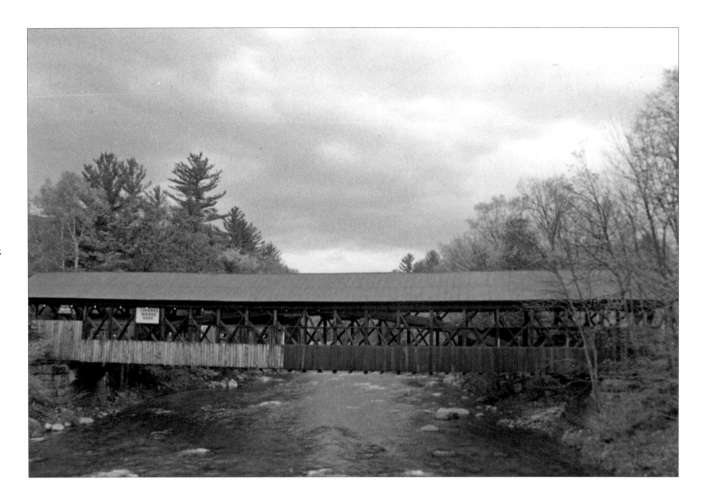

#50 Bartlett, Bartlett

Single span, 183 feet

Built in 1800, over the Saco River, and refurbished in 1857

Bypassed by highway in 1939 and rebuilt into a gift shop, "The Shoppe on the Covered Bridge"

West of US 302, 4½ miles east of Bartlett

Paddleford Truss, with added arch

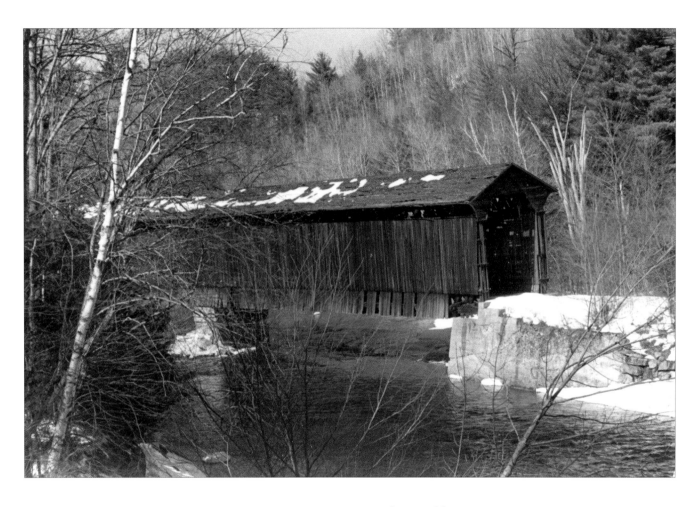

#57 Newport Pier, or Chandler Station

Claremont & Concord Railroad

Two-span, 217 feet

Built in 1871 by the Boston & Maine Railroad, over the Sugar River, rebuilt 1896 and again in 1907

This bridge is no longer in use for trains to pass upon.

Town-Pratt Truss

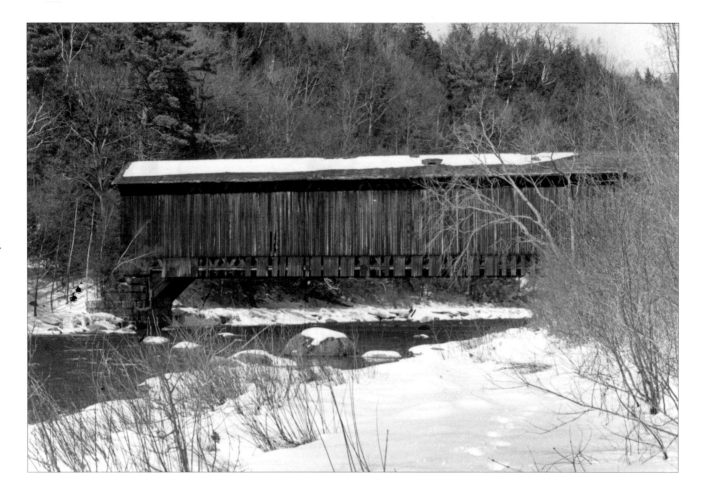

#58 Newport, Wrights

Claremont & Concord Railroad

Single span, 122 feet

Built in 1871 by the Boston & Maine Railroad, over the
Sugar River, rebuilt in 1895 and again 1906

This bridge is no longer in use and is not visible from the highway.

West of the Chandler Station

Town-Pratt Truss

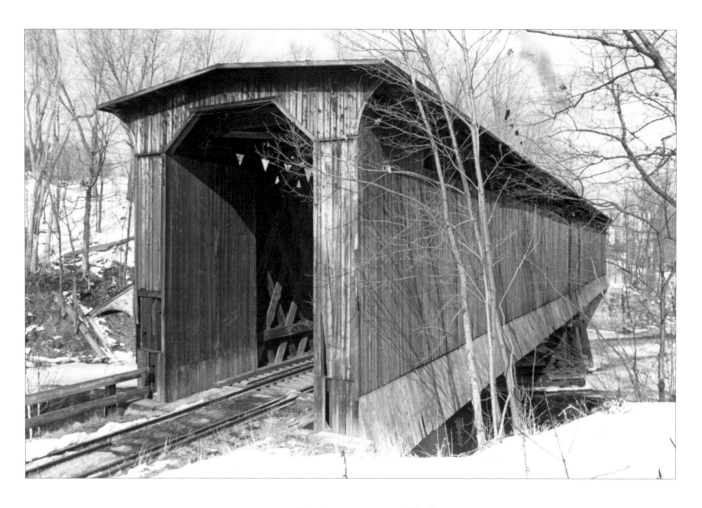

#60 Hillsboro, Hillsboro

Boston & Maine Railroad

Two-span, 219 feet

Built in 1903, over the Contoocook River

Destroyed by fire in 1985, and no longer visible

Town-Pratt Truss, sidewalk had been added

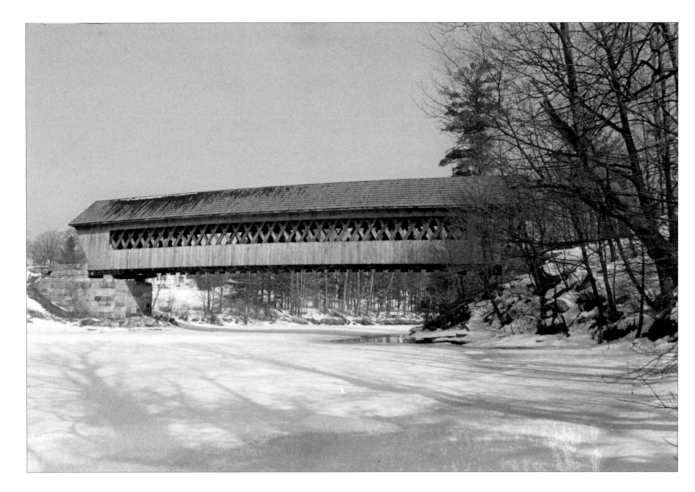

#63 Henniker, New England College

Single span, 150 feet

Built on land in 1972, oxen pulled the bridge over the Contoocook River into place during the winter months. This is the only authentic covered bridge built by traditional means in New Hampshire since 1912.

South of Route 9 in Henniker Village

Town Lattice Truss

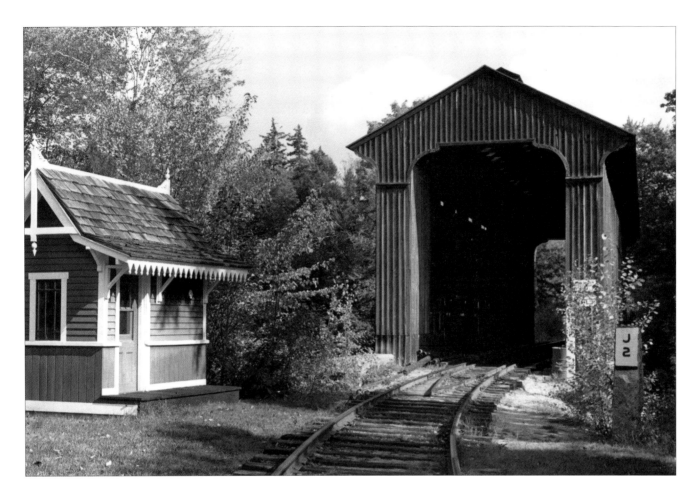

#64 North Woodstock, Lincoln

Clark's Trading Post, Railroad Bridge, White Mountain Central Railroad

Single span, 120 feet

Built in 1904 in Montpelier, Vermont, and later moved to New Hampshire, in 1964

This railroad bridge is used daily during the summer and fall seasons over the Pemigewasset River.

Howe Truss

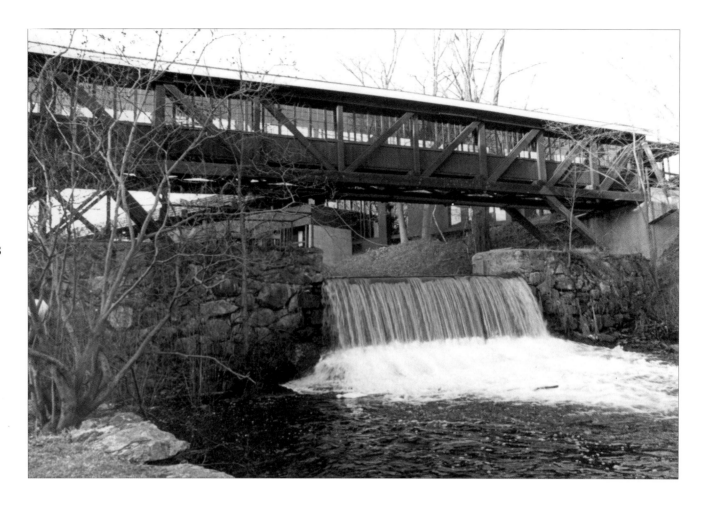

John Goffe Mill Bridge, Bedford

Single span, 125 feet

Built in 1962 as a walking bridge to pass over the Bowman Brook and waterfalls, and attached to the John Goffe Mill, which is on the National Register

This bridge has been moved to Wentworth over the Baker River.

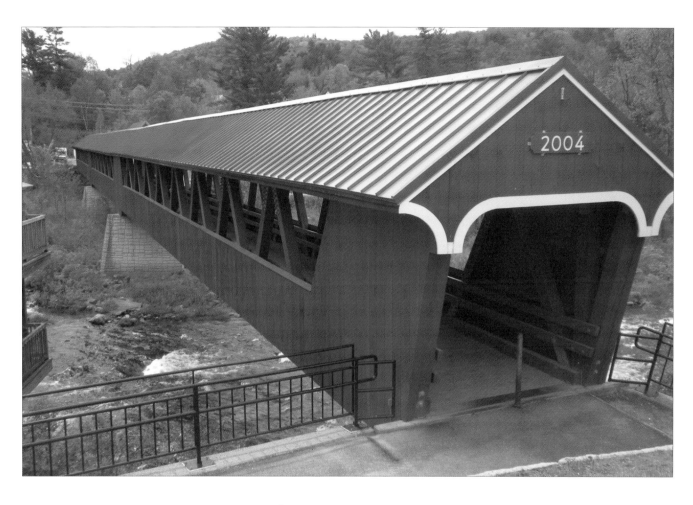

Littleton, Main Street

Two-span, over the Ammonoosuc River, beside the Little Grist Mill

Built in 2004, River District Redevelopment Project, redeveloped in 2014 to become a walking bridge that allows people to go from the parking area to Main Street near shops and cafes

Route 41

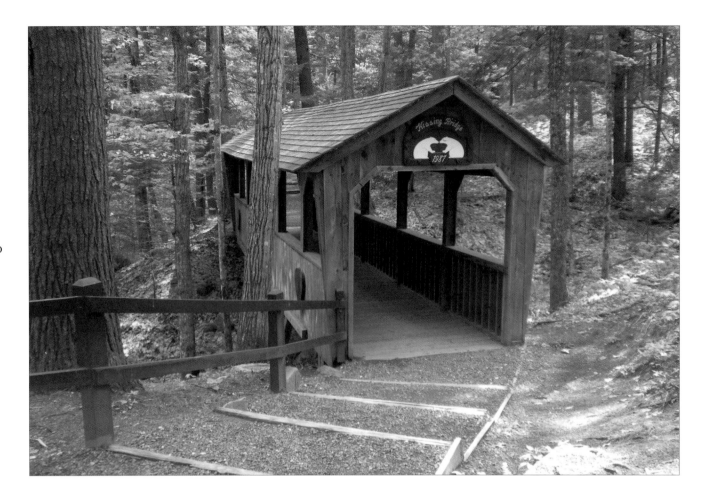

Rumney

Built in 1980 by the Polar Caves Park, this walk-through bridge is titled "Kissing Bridge" and features wooden decorative hearts on the sides.

Route 25

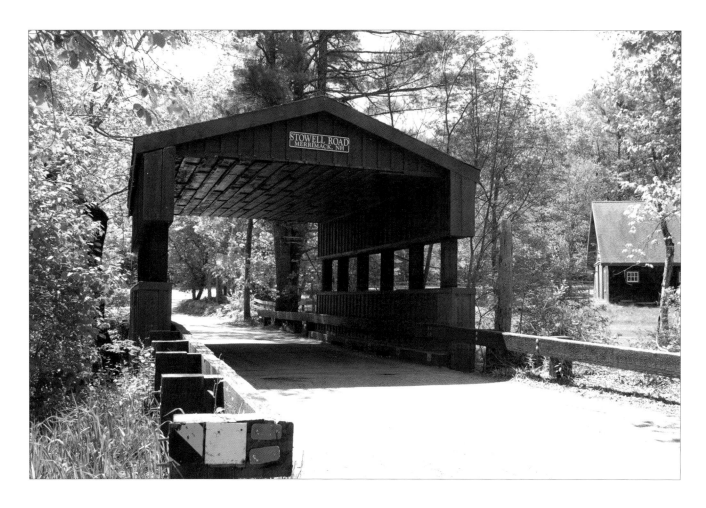

Stowell Road, Baboosic Brook Bridge, Merrimack

Built in 1990, owned by Town of Merrimack,
one lane, kit-form by Krenn Bridge Company, Michigan,
constructed by shiplap joints

Off Route 101

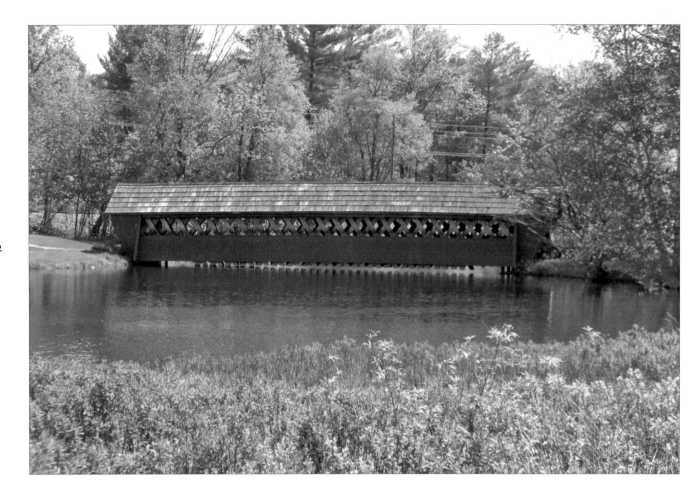

Woodstock, Lincoln

Single span, 76 feet

Built in 1987 over brook on the grounds of Jack O'Lantern Resort with golf course

Exit 30, I-93, on Route 3

Bridge Truss Frames

Covered bridges, built by different men at different periods of time, resulted in various types of frame structures. These are the main bridge trusses used to span the assorted waterways in New Hampshire.

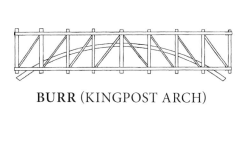

BURR (KINGPOST ARCH)

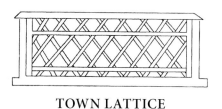

TOWN LATTICE

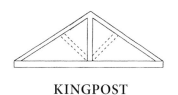

KINGPOST

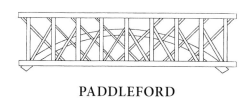

PADDLEFORD

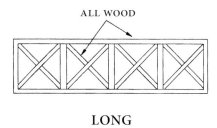

LONG

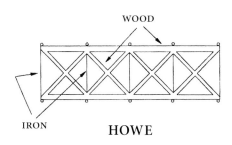

HOWE

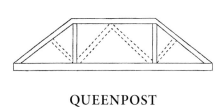

QUEENPOST

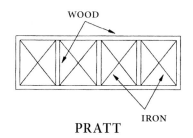

PRATT

Timeline of the Old Man of the Mountain

1805 Nathaniel Hall and Luke Brooks along with his companion Francis Whitcomb (surveyors) were the first men to report seeing the Profile.

1870 The Appalachian Mountain Club reports that the forehead boulder on the Old Man has slipped from the proper and is suspended in space.

1906 Climbing to the top of the Old Man's head, Reverend Guy Roberts takes measurements and discovers that the old man is in danger of falling.

1915 After stumping the state for 10 years to raise support for the Old Man's preservation, Rev. Roberts finally convinces quarry operator Edward Geddes to climb the mountain and take measurements resulting in the design of three heavy turnbuckles and a rod system to secure the forehead stone.

1916 Rev. Roberts and Mr. Geddes discover the forehead stone has slipped another ¼ inches and would topple with just four more inches. Geddes installs the reinforcement system, finishing the job single-handed in perilous weather. He was fifty-two years old.

1937 Edward Geddes, age seventy-four, goes and measures the stone he had secured and discovered it hadn't moved at all.

1938 A rock slide on Cannon Cliff buries the east of the highway with 15 feet of debris.

1945 The Old Man is made the official state emblem.

1948 Within 20 minutes, 2 slides occur—one on the north end of Profile Lake, the other at the south end, burying the highway in 15 feet of debris.

1953 Widening cracks in the forehead are discovered by hikers.

1954 A study initiated by the state confirms the widening of a large fissure across the top of the Old Man's forehead.

1955 President Dwight D. Eisenhower travels to the Granite State to visit the Old Man of the Mountain and to dedicate a stamp in his honor.

1957 The NH Legislature approves major repairs on the Old Man.

1958 From July 21 until October 20, major repairs were made on the Old Man, totaling $16,000 to anchor the upper forehead stone, fasten loose boulders, seal seams and fissures; fashioning a concrete gutter and bridging, and capping a 43-foot fissure.

1959 On October 24 a major rockslide covered the highway with 27-feet of debris, requiring 3½ days of round-the-clock work to clear the road.

1960 Adolphus "Dolph" Bowles and Austin Macauley, a state park's employee, was given the job of

Old Man's maintenance. Neils Nielson joins the inspection party as a worker.

1965 Niels Nielsen takes over as head of the Old Man's care-taking team.

1971 Cracks in the south face are sealed by Neils Nielson.

1976 With a high-speed highway proposed through the Notch, an environmental impact study is done on its possible effect on the Old Man. Part of it contained an elaborate $1.3 million project to link the blocks with steel, which never happened. The results: construction could go on, but carefully. California Governor Ronald Reagan visits the Old Man with former Hampshire Governor Hugh Gregg.

1979 U.S. Rep. James Cleveland forges a compromise to the super-highway proposal: the road would be built as a one-lane parkway through the Notch.

1987 Niels Nielsen is appointed the Old Man of the Mountain's official caretaker.

1989 Debbie Nielsen is the first woman in history to go over the edge of the Old Man's face and Niels Nielsen makes his last descent down the face, retiring as caretaker.

1990 David Nielsen takes his father's place as official caretaker.

1992 David Nielsen reports large cracks to what he notes as the "Keystone" and the "Arch Shaped Rock."

1993 Mike Pelchat fashions a canopy over the crack with fiberglass cloth and epoxy.

1997 The Old Man of the Mountain Museum opens in Franconia.

1998 David Nielsen files his last written report stating that "everything went great" and praising the new portable ram with which stress tests were conducted. Subsequent reports to state officials were given orally, with no indication of collapse.

2001 Niels Nielsen dies at the age of 74.

2003 On a foggy early morning on May 3, the Old Man of the Mountain tumbles into history.

Timeline provided courtesy of the Weirs Times, *"Old Man of the Mountain" Special Edition, 2003.*

"The Old Man Made His Notch in Time"

It is said that when the earth was going through the Ice Age and the granite was forming and the cliffs began to fall, many rock formations were developing. Through years of continuous freezing and thawing, the Old Man was beginning to take shape. As man walked the mountains in different ways, looking, looking and creating various paths, he discovered many things. Trails were discovered to waterways, falls, rock formations, the Old Man, the Indian Head, the Old Woman, Thunder Rock, Polar Caves and many more wonderful and exciting areas.

An outstanding development was the establishment of "The Old Man of the Mountain Legacy Fund." Friends of the Old Man raised money to create a viewing area at Profile Park, along the shore of Profile Lake in Franconia Notch State Park. This park allows the next generation to have an idea of what we had and enjoyed for so many years. The private nonprofit Legacy Fund provides a "lasting legacy of remembrance" for the Old Man of the Mountain. As of May 2017, over $600,000 had been raised, and the fund is still receiving donations.

—*Irene E. DuPont*
May 2017

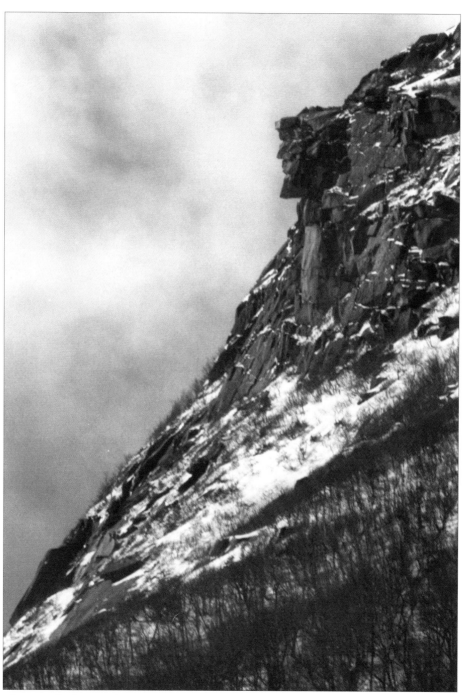

Photographed November 11, 2002

Bibliography

Allen, Richard Sanders., *Covered Bridges of the Northeast*, revised ed. Battleboro, VT: The Stephen Green Press, 1983.

Bennett, Randall H., *The White Mountains; Alps of New England*, Arcadia Publishing, 2003.

Caravan, Jill. *American Covered Bridges: A pictorial history.* Philadelphia: Courage Books, 1995.

Hill, Evan. *The Primary State.* Taftsville, VT:. The Country Press, 1976.

Johnson-Hancock, Frances Ann, *Saving the Great Stone Face*, Phoenix Publishing 1908.

Snow, Stan. *New Hampshire Covered Bridges.* Sanbornville, NH: Wake-Brook House, 1957.

Young, Conrad. *New Hampshire's Historical Covered Bridges; Watercolor Paintings & Facts on Existing Bridges.* Concord, NH, 2016.

The Weirs Times, "Old Man of the Mountain" Special Edition, Timeline, 2003.

New Hampshire Division of Travel & Tourism Development. PO Box 1856, Concord, NH 03302-1856.

About the Author

Irene E. DuPont received her BA from Notre Dame College, attended the Art Institute of Boston, Massachusetts College of Art and Design, Savannah College of Art and Design, Hallmark Institute of Photography, and attended summer sessions at The Maine Photographic Workshop. She was a faculty member of the Nashua School System for thirty-five years and taught in both the public and private sectors. In 1993, she was the recipient of a C-SPAN National Teacher of the Year Award for "Innovative Use of Cable in the Classroom." Irene is a juried member of both the Craftworker's Guild of Bedford, New Hampshire, and New Hampshire Made.

A talented and prolific artist, she has had numerous one-woman shows in New England. The most outstanding was at the Rotunda of the Cannon House, Washington, DC, sponsored by Time-Warner Communications.

Studying photographic techniques, Ms. DuPont was drawn to the old methods used to capture images on paper. The specialized printing processes, especially silver printing, offered a unique artistic outlet, creating a photograph whose statement spoke of a different time and lifestyle.

Enter the covered bridge. What more visible symbol of yesterday exists in New England? Through silver printing and hand coloring of each photograph, DuPont has brought to life again hazy summer days and the dark, cool interior of a covered bridge. All these images and more are reflected in New Hampshire's beautiful covered bridges.

This book is a dedication to recapturing bygone days.

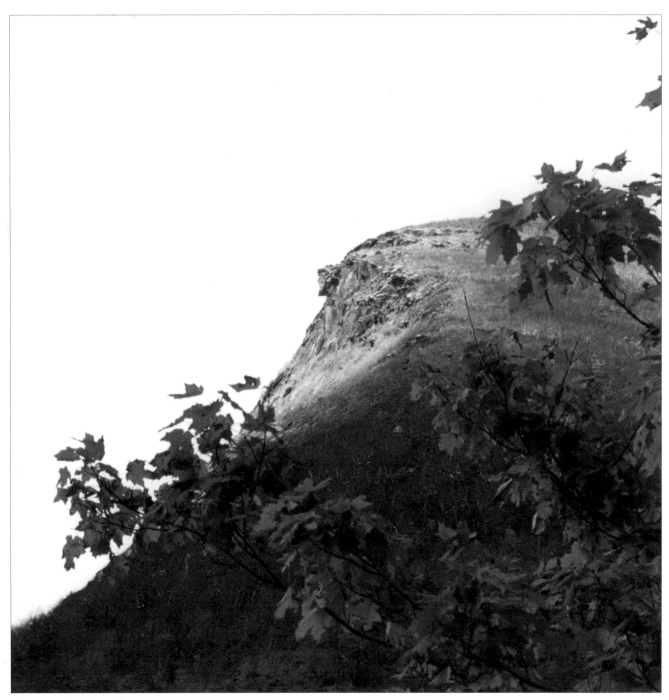

Photographed Sepember 13, 2002